IMAGES
of America

LAKE WALES

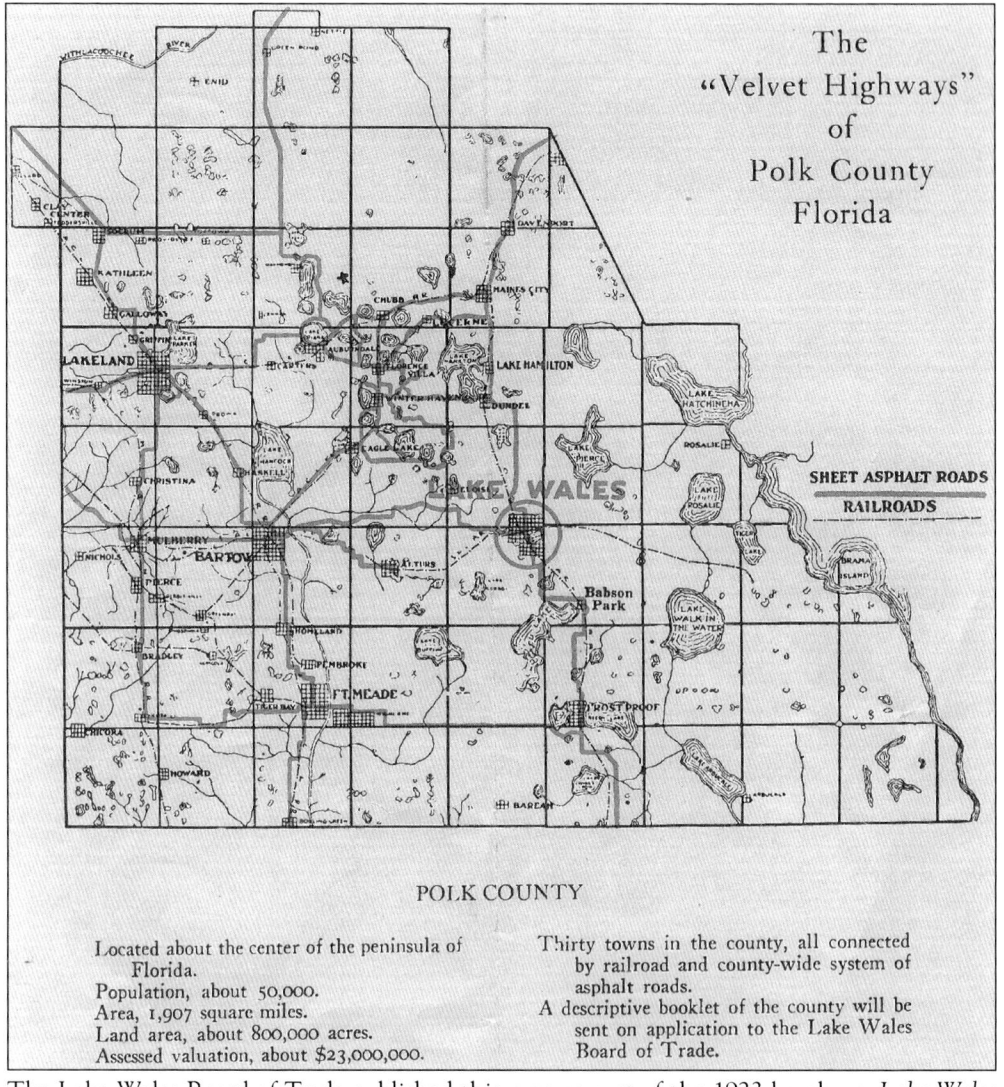

The Lake Wales Board of Trade published this map as part of the 1923 brochure, *Lake Wales Florida, Crown Jewel of the Scenic Highlands*. The promotional brochure was mailed out to inform prospective investors about opportunities for new businesses and home sites in the young town. Lake Wales and Polk County were proud to be the only place in the United States at the time with "Velvet Highways" connecting every town in the county. The Board of Trade later became the Lake Wales Area Chamber of Commerce. (Lake Wales Area Chamber of Commerce photograph; courtesy of the Lake Wales Public Library.)

ON THE COVER: Lake Wales welcomes the inaugural southbound run of the Seaboard Air Line Railroad, the *Orange Blossom Special* from New York City to West Palm Beach, Florida, on November 22, 1925. The train pulled into the Lake Wales Station, and several Lake Waleans joined the party of railroad officials and other dignitaries continuing on to Sebring. Standing on the train are, from left to right, an unidentified man, Katherine Alexander Boyte, Margaret Smith, first secretary of Lake Wales Area Chamber of Commerce Elizabeth Quaintance, Seaboard Air Line Railroad president S. Davie Warfield, and Roger Babson in the background. (Photograph by A. L. Alexander; courtesy of Historic Lake Wales Society and the Depot Museum.)

IMAGES of America
LAKE WALES

Jan Privett on behalf of
Lake Wales Main Street

Copyright © 2010 by Jan Privett on behalf of Lake Wales Main Street
ISBN 978-0-7385-8651-9

Published by Arcadia Publishing
Charleston, South Carolina

Printed in the United States of America

Library of Congress Control Number: 2010925443

For all general information, please contact Arcadia Publishing:
Telephone 843-853-2070
Fax 843-853-0044
E-mail sales@arcadiapublishing.com
For customer service and orders:
Toll-Free 1-888-313-2665

Visit us on the Internet at www.arcadiapublishing.com

To Mimi Hardman for her dedication to preserving history, and to the members of Lake Wales Main Street and Historic Lake Wales Society.

Contents

Acknowledgments		6
Introduction		7
1.	From Dream to Reality	9
2.	The Boom Time	29
3.	A Community's Spirit	55
4.	Business and Industry	77
5.	Community Recreation	89
6.	Area Attractions	103

Acknowledgments

I would like to thank all the members of Lake Wales Main Street and especially the Board of Directors who supported this project from the beginning. This book would not have been possible without the years of work done by Historic Lake Wales Society, the Depot Museum, and Mimi Hardman, president and director, in preserving the historic buildings, memorabilia, written materials, video documentaries, and the priceless photographs that so beautifully tell the story of our history. The City of Lake Wales manager and commissioners deserve our deep appreciation for caring enough about preservation to support the two organizations whose mission it is to preserve the town's history: Lake Wales Main Street and the Historic Lake Wales Society.

I sincerely appreciate the fascinating photographs contributed directly by Bok Tower Gardens, Chalet Suzanne, Mayer Jewelers, Struthers Honey, Alcoma Caretakers, LLC, and all the families over the years who have generously contributed their precious photographs to the Depot Museum. I also wish to thank the Lake Wales Public Library and Tina Peak, director, for the use of the library's photographic archives, and Tom Muir, curator of the Polk County Historical Museum, who was helpful in obtaining photographs from the Polk County Historical Association Collection. I am forever grateful to Mary Zipprer, a pioneer whose family was here before there was a town and who was herself an eyewitness to the growth of Lake Wales, for her contribution of knowledge and photographs.

Introduction

Lake Wales, "Crown Jewel of the Scenic Highlands," is located among rolling hills and sparkling lakes in the geographic center of Florida. Ancient geology often plays a subtle role in the development of a community as it did with Lake Wales, giving the area a different look from the majority of the state and creating the perfect soil and climate for growing citrus.

The Florida peninsula was shaped by the rise and fall of the seas as a result of the freezing and thawing of the polar ice caps. The Lake Wales Ridge is an ancient sand dune that was formed down the center of the state while most of the peninsula was under the ocean. From thousands of years as a chain of isolated islands, the ridge developed a different ecology from the rest of Florida. The highest ground in Florida, it is blessed with numerous spring-fed, sinkhole lakes and inhabited by unique species of plants and animals that are found nowhere else on earth.

Native Americans had camped and hunted in the ridge's dense pine forests for thousands of years. Ancient arrowheads and dugout canoes have been found, but there are no written records until the 1800s when a few white settlers created homesteads several miles from where Lake Wales would someday be.

The pioneers drawn to this area were mostly cattlemen—called "cow hunters" in those days. Wild cattle roamed free even after the cow hunters branded and claimed them. The Florida Fence Law requiring that cattle be penned was not passed until 1949.

The highest part of the Lake Wales Ridge could only be reached by soft sand game trails. Without wagon roads or a railroad cutting through the wilderness, the area was too inaccessible to be of interest to most settlers, but one man's dream changed that.

In 1902, George Vernon ("G. V.") Tillman ventured into the untamed woods and fell in love with the natural beauty of the area around Lake Wailes, which had been named for a state land agent. He dreamed of a prosperous city built from the timber of the pine forest and supported by the turpentine the trees would yield. Citrus groves and cattle on the fertile land would add to the wealth of the new community and attract visionary settlers who wanted to build a quality town.

Tillman's dream remained just that until 1905 when he invited three businessmen to meet him in Bartow, Florida, and join him on the difficult, 20-mile journey through the wilderness to investigate his vision of an ideal city beside Lake Wailes. C. L. Johnson, B. K. Bullard, and E. C. Stuart grasped Tillman's vision, and the four men incorporated the Lake Wales Land Company on April 10, 1911. The name of the town then became Lake Wales, dropping the "i" from Wailes because it sounded too much like a mournful cry to be good for promotional purposes. The name of the lake, however, remained Lake Wailes.

Many towns grow slowly over time and often quite by an accident of fate. Settlers are usually drawn to geographic attractions like a river, a busy port that serves shipping, or another type of industry that offers job or investment opportunities. Towns do not usually spring up from the wilderness and become a city instantaneously without the influence of something like a gold rush, but fortunately, Lake Wales *could* offer its early settlers gold—golden fruit, that is. Many

settlers dreamed of building their home in an orange grove that would support them financially for the rest of their lives.

The phenomenal growth Lake Wales experienced in the early years would not have been possible without the arrival of the railroad in June 1911. After just two years, Lake Wales had the elegant Hotel Wales, a Presbyterian church, a train depot, a boardinghouse, general store, hardware store, real estate office, turpentine complex, citrus grove, sawmill, waterworks building with a 1,000-foot-deep well, blacksmith, livery stable, an ice plant, and the Power and Light Company. With all this in place and the railroad running three times a day, the Lake Wales Land Company began sending beautiful brochures to major cities in Southern and Northern states to attract entrepreneurs and home-seekers. They promoted the rolling hills, clear lakes, balmy climate, and the healthful advantages of the Florida air. Investors were guaranteed that if they were unsatisfied at the end of one year, the company would reimburse them.

Even in the early years when Lake Wales only had sand-rut roads, it was never a wild and lawless frontier town. Instead it was the only ridge town that had been a "planned community" from its inception. From the beginning onward, the community's emphasis was on education, arts and culture, community spirit, and warm Southern hospitality.

The founding fathers would no doubt be amazed at the changes in their ideal city today, but they would certainly recognize Lake Wales; much of what they built has been preserved and still appears as it did in the 1920s. The Lake Wales area has four national historic districts: Historic Downtown Lake Wales, the Olmsted Residential Historic District, North Avenue Historic District, and the Mountain Lake Estates Historic District. The town's crowning glory, a great masterpiece of art, music, and nature, is the Bok Tower Gardens National Historic Landmark, which has made little Lake Wales a destination for international travelers and given it the nickname, the "City of Bells."

And so the founding fathers' dreams came true. Lake Wales is a quality town built by visionary people, and it has stood the test of time.

One
FROM DREAM TO REALITY

Until the 1800s, only Native Americans and a few white hunters from distant settlements had roamed the virgin forests where Lake Wales would someday be. Chief Chipco was a famous Seminole Indian who refused to fight in the last Seminole war and became known as a friend to whites. Shown here with a young relative, he lived on Lake Marion a few miles from Lake Wales. (Courtesy of Polk County Historical Association, Polk County Museum.)

This turpentine distillery was located in the Kissimmee River area in southeastern Polk County in the late 1800s. Thick, old-growth longleaf pine forests covered most of Florida and stretched up into North and South Carolina in those days. The pioneers found many more uses for the pine trees than just turpentine, including lumber for homes and wood for tools and furniture. (Courtesy of Mary Zipprer.)

A few miles west of Lake Wales was Enterprise, a settlement shown in this early 1900s photograph. The people who lived there were vegetable farmers, citrus growers, and cattle ranchers. When the government dug canals around the settlement to drain the flat, low land, cows grew sick and died of starvation on the overly dry pastures. After that, the area became known to locals as "Sick Island." (Courtesy of Mary Zipprer.)

Pictured here is the Steve Clark family in the late 1800s in front of their home located a few miles from the future site of Lake Wales. After recovering from wounds received fighting in the Civil War, Clark moved his family from Georgia to Florida. The pioneer families drawn to southeastern Polk County in the 1800s were mostly cattlemen and farmers. (Picture from Mary Zipprer; courtesy of Polk County Historical Association, Polk County Museum.)

Many rural schools in the early 1900s were one-room buildings constructed by the local community with lumber from nearby trees. The school pictured here was located near Lake Rosalie. These unidentified children were fortunate to have a school building since many rural areas were unable to even provide a teacher. William and Evelyn Zipprer attended this school until the first school opened in Lake Wales in 1914. (Picture from Mary Zipprer; courtesy of Polk County Historical Association, Polk County Museum.)

Elbert, Emma, and Mae Wood are seated in the front seat of this carriage near Lake Rosalie in the early 1900s. The women and children in the back seat are unidentified. A trip to town in a horse-drawn carriage could take a day or two when most of the countryside had no roads like the one shown here. Wagons would often get mired in the soft sand. (Courtesy of Mary Zipprer.)

Will Hancock plays the popular game of croquet with Mae and Emma Wood in this early 1900s photograph. An unidentified woman enjoys the shade of the porch in this homestead on Lake Rosalie near Lake Wales. This was Mary Zipprer's grandmother's home; Mary spend many days here. She later became a teacher in Lake Wales. (Courtesy of Mary Zipprer.)

Aaron Gideon Zipprer (not shown here) was released from duty during the Civil War to return to Polk County and supply cattle to the Confederate army, something many Central Floridian cattlemen did during the war. His descendants lived a few miles from Lake Wales on Lake Rosalie. Like most area residents, they raised cattle, citrus trees, and vegetable crops. This photograph was taken about 1920 of the Zipprer family dressed for a social occasion. (Courtesy of Mary Zipprer.)

As a teenager, Mary Zipprer rides her favorite horse in this 1930s photograph taken near Lake Rosalie. Her pioneer family was here before there was a town, and she was an eyewitness to the town's birth and growth. She contributed to the education of Lake Wales children as a teacher. Now retired, she has continued to educate younger learners by donating several pictures to this project. (Courtesy of Mary Zipprer.)

In 1903, Merdic Washington Keen and his wife, Allison, homesteaded property in the Lake Wales area. Today their descendants continue as successful cattle ranchers near Lake Wales. This photograph was taken by Dr. Jim Keen from Miami in 1937. From left to right are (seated) Allison Keen and Merdic Washington Keen; (standing) Sam Keen, Roy Keen, and Barney Keen. (Courtesy of Historic Lake Wales Society and Depot Museum.)

Sam Keen Sr. holds Sammy Keen Jr. in a photograph taken on Buster Island near Lake Wales in 1941. This scene shows how a typical cow camp would have looked in the 1800s. Today a detailed replica of a cow camp is on display for visitors to Buster Island, which is now part of the Kissimmee River State Park. (Courtesy of Historic Lake Wales Society and Depot Museum.)

Sam and Paul Keen are seen here on horseback around 1939, counting cattle as they come through a gate. Except for the fence, the scene would have looked much the same in the 1800s. Wild cattle roamed free on open range in those days until cow hunters branded and claimed them. The branded cattle still grazed free of fences and had to fend for themselves against attacks by predators like the Florida panther. "Cracker," the pejorative term for whites, came from the noise the cattleman's long whip made as he drove the herd to market. Polk became Florida's first "no-free-range" county when leaders passed a fence law in 1923. (Courtesy of Historic Lake Wales Society and Depot Museum.)

Steamboats carried passengers along central Florida rivers in the 1800s until roads were built and automobiles began to carry people and cargo. The unidentified passengers in this early 1900s photograph are on an excursion down the Kissimmee River on the steam-powered paddleboat *Roseada*. (Courtesy of Mary Zipprer.)

Buck Lake (later Mountain Lake), seen here in the early 1900s, was typical of the area that became Lake Wales. The surfaces of the region's spring-fed lakes were broken only by the movement of abundant fish and alligators. Rolling hills had thick pine forests teemed with both game and predators. (Courtesy of Historic Lake Wales Society and Depot Museum.)

In 1902, G. V. Tillman ventured into the untamed woods near Lake Wailes and was so impressed by the natural beauty that he dreamed of a new city among the gentle hills and spring-fed lakes. Born in 1861, Tillman died in 1933. (Courtesy of Historic Lake Wales Society and Depot Museum.)

In 1905, Charles Leon "C. L." Johnson (pictured here in later years), B. F. Bullard, and his son B. K. Bullard accompanied G. V. Tillman and "Old Jack" Jordan on the difficult, 20-mile journey through the wilderness from Bartow, Florida, to investigate Tillman's vision of a new city near Lake Wailes. Born in 1871, Johnson died in 1953. (Courtesy of Historic Lake Wales Society and Depot Museum.)

Born in 1881, Bernice Kennedy "B. K." Bullard was an officer of the Sessoms Investment Company, which had turpentine and timber operations and controlled over 98,000 acres on the Florida ridge in 1905. One of the founders of Lake Wales, he became director of the Lake Wales Land Company. Bullard later served in the Florida House of Representatives from 1922 to 1932. He died in 1942. (Courtesy of Historic Lake Wales Society and Depot Museum.)

Born in 1852, Edward Crosland "E. C." Stuart was a wealthy Bartow businessman with large landholdings and interests in banking and phosphate. He joined Tillman, Johnson, and Bullard to form the Lake Wales Land Company and was made its president when the company was incorporated on April 10, 1911. Stuart died in 1942. (Courtesy of Historic Lake Wales Society and Depot Museum.)

Allen Carlton "A. C." Nydegger, a 24-year-old from Winter Haven (seated on the far right), camped with his crew while surveying the area that would become Dundee, Florida, in 1911. After seeing Nydegger's drawings of Dundee on file in Bartow, Tillman and the other founders hired Nydegger to plat and survey Lake Wales. (Courtesy of Historic Lake Wales Society and Depot Museum.)

Nydegger was to meet Tillman at Lake Wailes in the early summer of 1911. He stopped to ask directions at the homestead of Rollie Pinkston (shown here in a later photograph) a few miles north of Lake Wailes. Even with directions, the survey crew got temporarily lost in the dense wilderness until Tillman found them. (Courtesy of Historic Lake Wales Society and Depot Museum.)

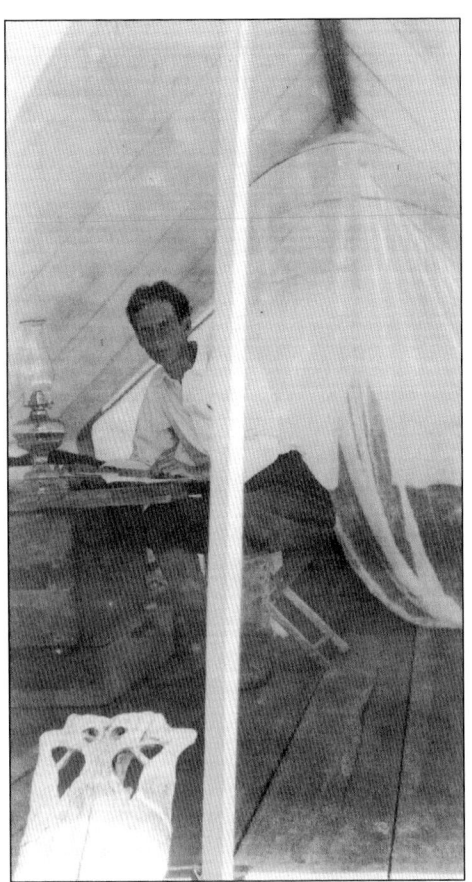

A. C. Nydegger works at his desk on the drawings made while surveying the 5,000 acres owned by the Lake Wales Land Company. Mosquito netting over the bed in the background made it possible to sleep at night. On rare restful nights, the alligators did not bellow and nocturnal birds like owls, chuck-wills-widow, and mockingbirds did not disturb the survey crew's sleep by singing nearby. (Courtesy of Historic Lake Wales Society and Depot Museum.)

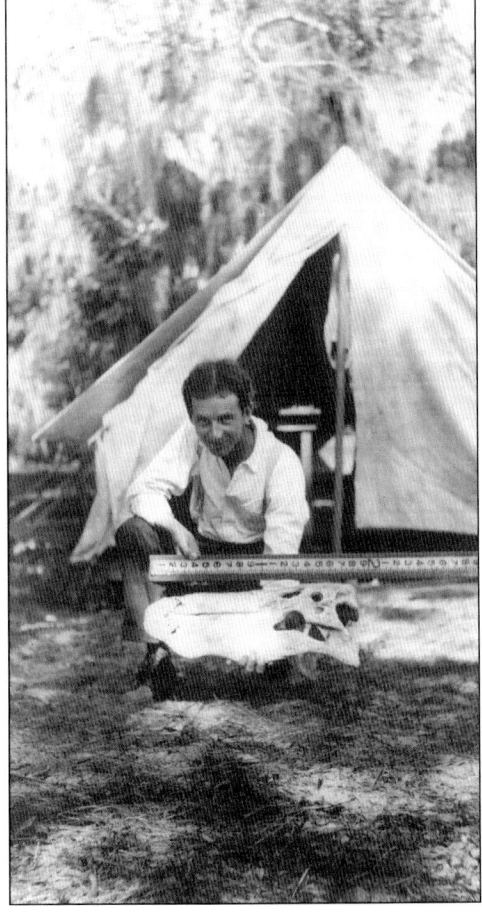

Of all the dangerous predators in the area, alligators, some measuring well over 12 feet long, would have been the most threatening, especially since the crew skinny-dipped in the lake to cool off every day at noon. In this 1911 photograph, Nydegger holds a surveyor staff, showing that just the skull of this alligator was about 2 feet long. (Courtesy of Historic Lake Wales Society and Depot Museum.)

In this photograph of the Nydegger camp on the south shore of Crystal Lake, an unidentified survey crew member sits in the shade to read. The men worked for 10 weeks mapping out the city of Lake Wales. The wooden fence in the foreground, low enough to step over, was built to keep out wild cattle and hogs. (Photograph courtesy of Lake Wales Library.)

Nydegger's Lake Wales survey crew takes a break to pose with their equipment in this early 1911 photograph. From left to right are James Tillman (son of G. V. Tillman), Robert Hatton, A. C. Nydegger, and two unidentified crew members. (Photograph courtesy of Lake Wales Library.)

The Lake Wales Land Company began harvesting turpentine from the pines around Lake Wailes before the town was built. A tent camp was set up for workers, and a distillery, called the "still" by locals, was constructed on the northeast side of Lake Wailes. (Courtesy of Historic Lake Wales Society and Depot Museum.)

Carlos Drew "C. D." Ahl, shown here on the left, was brought to Lake Wales to manage the turpentine operations. His wife, Martha Adams Ahl, on the right, joined him later, bringing their young children, Jack Owen Ahl and Janyce Barnwell Ahl. The Ahls were the first family to live in Lake Wales. (Courtesy of Polk County Historical Association, Polk County Museum.)

The Atlantic Coast Line Railroad arrived in June 1911. This early 1913 photograph taken from the water tower looking south shows, from left to right, the Presbyterian church, a train depot, a two-story boardinghouse, a general store, a hardware store, and a real estate office. The new Hotel Wales is out of frame to the left. By the end of the year, the town also had a turpentine complex, a citrus grove, a sawmill, a waterworks building with a 1,000-foot-deep well, a blacksmith and livery stable, ice plant, and Power and Light Company. With all this in place, and the railroad running three times a day, the Lake Wales Land Company began publishing promotional brochures. (Courtesy of Historic Lake Wales Society and Depot Museum.)

The Hotel Wales, shown in this early 1913 photograph taken from the water tower looking east, was completed in September 1912. It faces what would become Scenic Highway in the foreground. Behind the hotel is Crystal Lake, which was connected at the time by a short creek to the larger Lake Wailes in the distance. The grounds were neatly landscaped with a variety of trees, including palms along the cement sidewalks and fruit trees, flowering trees, and shrubs. On the far left of the photograph is the hotel's engine house, which generated electricity and pumped water from the 285-foot-deep well. The 22-room hotel had all the modern amenities, including electric lights, hot and cold running water in every room, an ice plant, and 12 fireplaces. The hotel even had telephone service—with wires strung on living pine trees all the way to Bartow. The Lake Wales Land Company built the hotel and had an office on the first floor. (Courtesy of Historic Lake Wales Society and Depot Museum.)

Maggie Harris was the first hotel manager and "Old Jack" Jordan was hired as the cook and porter. Many new citizens of the town lived in the hotel while their homes were being built. The town's first church services were held in the elegant hotel, as were many later weddings, proms, parties, and celebrations. (Courtesy of Historic Lake Wales Society and Depot Museum.)

The Hotel Wales had several owners over the years and underwent many upgrades and remodelings. Even the hotel's name changed several times. Nonetheless, the warm welcome of Southern hospitality was ever present. Having been the center of community gatherings and fellowship for 67 years, the hotel built by the founding fathers served its last meal in April 1979. That evening, a fire brought down the landmark, and the people of Lake Wales mourned its loss. (Courtesy of Historic Lake Wales Society and Depot Museum.)

The first house in Lake Wales was built by L. Z. Tate in 1912 for the Lake Wales Land Company out of lumber left over from Hotel Wales. It was used as a guesthouse for the company. Located at the corner of Park Avenue and Third Street, it was called the Tate House until the J. A. Caldwell family moved into it in 1918. (Courtesy of Historic Lake Wales Society and Depot Museum.)

Thomas Jefferson Parker (also known as "T. J." or "Tom") and his wife, Julian Hankens Parker, moved to Lake Wales in May 1912. Their first residence was the second floor of Parker's General Store, which they had built on Park Avenue. Later they lived in this large bungalow home, which was built for them on the corner of Park Avenue and Scenic Highway. (Courtesy of Polk County Historical Association, Polk County Museum.)

In May 1914, C. L. Johnson; his wife, Eliza Belle Riggins Johnson; and their children—Maud, Irene, Robert, Louise, Alexander, and Thalia—moved into their beautiful, spacious two-story home on Sessoms Avenue. Johnson is shown here with his youngest daughter, Thalia, on Alice the pony. The woman watching from the porch is probably Eliza Johnson. (Courtesy of Historic Lake Wales Society and Depot Museum.)

Eliza Belle Riggins married C. L. Johnson in 1893 in their hometown of Blackshear, Georgia. The Johnsons and their six children moved to Lake Wales and lived in the Wales Hotel in 1911 while their home was being built. Here Eliza reads to her children, Alex and Thalia, in their home overlooking Crystal Lake on Sessoms Avenue. (Courtesy of Historic Lake Wales Society and Depot Museum.)

The Tillman family had a reunion in the late 1920s at the Tillman home. Seen here from left to right are (seated) G. V. Tillman, Effie Tillman, G. V. Tillman Jr., Eliza Tillman holding Ola Belle Tillman, and Maj. James M. Tillman; (standing) Spurgeon Tillman, Dr. G. C. Tillman, an unidentified woman and man, "Grandma" Spencer, Walter Tillman, Rollie Tillman, and Dr. O. G. Tillman. (Courtesy of Historic Lake Wales Society and Depot Museum.)

J. Walker Pope, left, and G. V. Tillman, right, are shown on the north side of Crystal Lake in about 1914. On the far side of the lake from left to right are the homes of Dan McCorquodale, W. L. Ellis, and A. C. Thullbery, as well as the Presbyterian church. (Courtesy of Historic Lake Wales Society and Depot Museum.)

Two
THE BOOM TIME

The Land Company began sending brochures advertising the "natural loveliness" of the community to major cities in Southern and Northern states in 1913. Many people came to see for themselves, and many went back only to settle their affairs so they could return to Lake Wales. This c. 1920 photograph shows the Ridge Properties limousine for prospective land buyers parked in front of Crystal Lake. (Courtesy of Historic Lake Wales Society and Depot Museum.)

Jesse T. Rhodes, wife Alice May, and sons Kenneth and Morris came to Lake Wales in 1913. Rhodes, a contractor, built many homes and businesses in town. In 1915, he was contracted to construct a large two-story brick building on the south side of Park Avenue. He bought it himself before it was complete and put J. T. Rhodes across the top of the building. (Courtesy of Historic Lake Wales Society and Depot Museum.)

This early 1916 photograph of Park Avenue looking east shows the Lake Wales State Bank on the left. Next to it is the J. T. Rhodes building. All the other buildings were wood-frame construction. On the far right is T. J. Parker Bank, and behind that is Parker's General Store. (Courtesy of Historic Lake Wales Society and Depot Museum.)

The first schoolhouse was built in 1914 by Lake Wales Land Company. The Polk County Board of Public Instruction turned down a request for a teacher and desks on January 6, 1914, because there were only nine children in town and the county required 10 students to form a school district. C. L. Johnson did not let that stop progress. He sent a large wagon to "Sick Island" to get Bud Lindsey, his wife, and the couple's eight children and moved them into a house in town. Now they had 14 students, and the county granted the district. The two-room school opened January 20, 1914, with Maud Blackburn as the first teacher. This photograph from the fall of 1914 shows school principal Harry Hanson with some unidentified "young scholars," as they were called then. Many years later, the schoolhouse was remodeled and moved across the street to become the Zipprer family home. (Courtesy of Historic Lake Wales Society and Depot Museum.)

The Seaboard Air Line Railroad arrived in Lake Wales on April 5, 1915. As the place where the east-west Seaboard Airline crossed the north-south Atlantic Coast Line, Lake Wales had the finest railway facilities in the state. This c. 1920 photograph looks east on Park Avenue and shows an Atlantic Coast Line steam engine stopped at the depot on Scenic Highway. (Photograph by Alexander; courtesy of Historic Lake Wales Society and Depot Museum.)

Dr. W. Luther Ellis came to Lake Wales in January 1916 and became the town's first dentist, with an office on the second floor of the Lake Wales State Bank on Park Avenue. Ellis was so popular that wealthy Northerners who spent winters in Lake Wales would wait until they came south to have their dental work done. Ellis treated patients until his death in 1947. (Courtesy of Historic Lake Wales Society and Depot Museum.)

Both domestic and wild hogs, also called razorbacks, roamed free on the sandy, unpaved streets and alleys of Lake Wales in the early days. This photograph, taken around 1916, shows electric poles that were placed in the alleys behind buildings for aesthetic reasons. (Courtesy of Historic Lake Wales Society and Depot Museum.)

This unidentified little boy sits in an old automobile, called simply a "machine" in those days. The photograph was taken near the Lake Wales depot before 1916. Atlantic Coast Line Railroad boxcars are visible in the background. (Courtesy of Historic Lake Wales Society and Depot Museum.)

Walter Jackson Langford and his wife, Barbara Stalls Langford, moved to Lake Wales with children Jessie, Roy, and Elmer and built a home on Polk Avenue in May 1916. In this 1917 photograph, Langford sits in the horse-drawn dray, or wagon, that he used in his transfer business. He also grew vegetables in his garden and sold them from this wagon. (Courtesy of Polk County Historical Association, Polk County Museum.)

"Prince Dennis," a 32-inch-tall adult and his dog, Tige, put on a shoe demonstration on Park Avenue in late 1916. He told jokes and, of course, urged kids to buy Buster Brown shoes. Between 1904 and 1930, the Brown Company had over 30 costumed boys and adult of unusually small size portraying "Buster," the five-year-old comic-strip character, in shows across America. (Photograph by Alexander; courtesy of Historic Lake Wales Society and Depot Museum.)

Many of the early pioneers of Lake Wales were enjoying a picnic at Crystal Lake Park in this winter 1918 photograph. Seen here from left to right are children Helen Jones (daughter of R. N. Jones), Paul Morris (seated), Gertrude Jones, Ruth Jones, and two unidentified children. The adults, also seen from left to right, are (seated) an unidentified man, Rose Wetmore, and Mrs. T. L. Wetmore; (standing) another unidentified man, A. C. Thullbery, Myrtle Jones (the daughter of A. C. Thullbery), Theo Wetmore, an unidentified woman, Mrs. A. C. Thullbery, an unidentified woman, Clarence C. Thullbery, Mrs. M. M. Ebert, an unidentified woman, Milo M. Ebert, Joseph "Booster" Briggs, two unidentified men, R. N. Jones, and Harry Crann (publisher of the Highlander newspaper from 1918 to 1920). (Courtesy of Historic Lake Wales Society and Depot Museum.)

The fact that the Lake Wales school went from a one-room building with only eight students to this modern, two-story brick schoolhouse with over 100 students in just four years shows both the community's growth and its deep commitment to education. At that time, most small communities only offered classes up to the 10th grade. This school opened in 1919 and offered grades 1–11 from its very first year. (Courtesy of Historic Lake Wales Society and Depot Museum.)

Students—including these children from around Starr Lake—were bused to the new Lake Wales School from outlying areas in 1919. The unidentified students are holding up bottles of milk. Behind the students is the first school bus. (Courtesy of Historic Lake Wales Society and Depot Museum.)

By the time A. L. Alexander took this photograph in late 1919, a total of 193 students were attending the Lake Wales School. To the far left of the students and teachers are uninhabited rolling hills, most of them planted in citrus. (Courtesy of Historic Lake Wales Society and Depot Museum.)

Pictured in front of the school in this 1920 photograph is Lake Wales's 10th grade class, which would have been the graduating class at most rural schools. Students interested in completing 11th and 12th grades would have had to a travel to a larger city to continue their educations. (Courtesy of Historic Lake Wales Society and Depot Museum.)

Shown here during the 1920–1921 school year on the front steps of the Lake Wales School are the first 11th grade students ever to attend classes in Lake Wales. Most of the students seen here would begin full-time employment at the end of the school year; only six of these them would graduate 12th grade the following spring. From left to right, they are (first row) Charles Perry, J. D. Walker, Roma Fraser, Bern Bullard, Roy Wetmore. Ross Anderson, Clifford Watterson, and Spurgeon Tillman; (second row) Gertrude Jones, Olive Kelly, Esther Caldwell, Frances Campbell, Gladys Driggs, Marian Brantley, Hazel Kirch, and Alice Briggs; (third row) teachers Rachel Morris and Mr. Childers, Warren Bartleson, Reggie Jones, Cecil Kincaid, Louise Driggs, an unidentified girl, Margaret Lipinski, Marie Kirch, and Prof. E. M. McCulley; (fourth row) Roy Wilhoyte, Wanda White, Lehman Carmichael, Gettis Riles, and William Edwards. (Courtesy of Historic Lake Wales Society and Depot Museum.)

This 1922 photograph shows the first class to graduate from 12th grade at the Lake Wales School. There were 396 students that year in all grades combined. Shown here from left to right are (seated) Mildred Brantley, Gertrude Jones, Hazel Kirch, and Frances Campbell; (standing) Florence Everett and Esther Caldwell. (Courtesy of Historic Lake Wales Society and Depot Museum.)

A. L. Alexander was the first professional photographer in Lake Wales. He shot this c. 1918 photograph from his cottage, which was also his studio, on the north side of Park Avenue, block 26. Across the street is Brantley's grocery store. (Courtesy of Historic Lake Wales Society and Depot Museum.)

The woman and man in this 1916 photograph stand outside the office of the town's first newspaper, the *Lake Wales Highlander*. A. R. Nason was the owner and editor of the publication. The office was located at the corner of Park Avenue and Market Street. (Courtesy of Mary Zipprer.)

The Lakeview Inn opened in October 1920 on the southwest corner of Scenic Highway and Central Avenue. The dining room could seat 100 guests. The owners lived on the first floor, and the second floor contained 50 guest rooms. (Courtesy of Historic Lake Wales Society and Depot Museum.)

This 1920 photograph was taken from Scenic Highway looking northwest at the 1919 Bullard Building on Stuart Avenue. The largest building in town, the brick structure was also known as the Bullard Block. By the time of this picture, the streets have been improved from sand to clay. Notice that the two white containers on the left (on the sidewalk of the Scenic Garage) are marked "high proof gasoline." (Courtesy of Historic Lake Wales Society and Depot Museum.)

The City of Lake Wales built this little bungalow known as the Crystal Lodge on Crystal Lake in 1920. It was used by the Lake Wales Woman's Club until 1938 when the Lake Wales Area Chamber of Commerce began using it for their office. The building has been moved next to the Depot Museum on Scenic Highway and is now the Children's Museum. (Courtesy of Historic Lake Wales Society and Depot Museum.)

A group of local businessmen built these two structures in 1920 on the south side of Stuart Avenue near Scenic Highway. On the left is the Scenic Theater and on the right is the Crown Café. (Courtesy of Historic Lake Wales Society and Depot Museum.)

Lewis H. Parker contracted Jesse T. Rhodes to build the modern, one-story brick building on the left, on East Park Avenue for the L. H. Parker and Son business. This 1922 photograph is looking east on Park Avenue, still a clay-surfaced road. Barely visible at the end of the street is a banner with electric lights that reads, "Welcome to Lake Wales." (Courtesy of Historic Lake Wales Society and Depot Museum.)

In 1925, looking west on Park Avenue from Scenic Highway, the Lake Wales State Bank stands on the far left and the Citizens Bank (no relation to the current Citizens Bank) looms on the right. The town is clearly thriving, and the street is finally paved. (Courtesy of Historic Lake Wales Society and Depot Museum.)

The first stage of the Rhodesbilt Arcade on Park Avenue was completed in 1924 by contractor J. T. Rhodes. The hall seen through the archway in the center would eventually connect with the second phase of the arcade on Stuart Avenue. This photograph was taken soon after this first phase was finished. (Courtesy of Historic Lake Wales Society and Depot Museum.)

In 1926, the second phase of the Rhodesbilt Arcade, shown here on the left, was completed by J. T. Rhodes on Stuart Avenue. Shoppers could walk through the center of the building from the Stuart Avenue side to the Park Avenue side of the Rhodesbilt Arcade. This 1926 photograph looks east down Stuart Avenue from the top of a two-story building across the street. (Courtesy of Historic Lake Wales Society and Depot Museum.)

A new Gothic-style Lake Wales High School opened on August 30, 1926. The school was built to serve as a community center. The auditorium could hold 1,200 people, almost half the population of Lake Wales. Community events were held there, including Sunday afternoon band concerts. (Courtesy of Max Mayer, Mayers Jewelers.)

Students enjoyed many happy times at the high school over the years. Seen from left to right in this 1940s photograph are Charles Thullbery, Frank Hunt, Betty Buchanan, Roy Craig Jr., Jessie Sprott (seated in the foreground), Earl Norton (standing behind the car), and Molly Craig (standing in front of the car). (Courtesy of Historic Lake Wales Society and Depot Museum.)

The high school was gutted by fire in 1974. The loss of the school was devastating to Lake Waleans, many of whom wanted to keep a brick as a memento. Thirty years later, graduates of the school could still quote the bronze plaque by the entrance that had read, "Enter these halls with an open mind, an open heart, and a willingness to learn." (Courtesy of Historic Lake Wales Society and Depot Museum.)

This panoramic scene was the view passengers arriving by train would have seen in 1925 Lake Wales. Panning from left (south) to right (north) along Scenic Highway is the corner of Stuart Avenue, the alley between the Bullard Building and the Lake Wales State Bank, Park Avenue (straight ahead looking west), and the water tower in the distance. (Courtesy of Historic Lake Wales Society and Depot Museum.)

The Lake Wales Post Office moved to this new building on West Park Avenue in 1927. Seen here from left to right are (seated) Max McClannahan, Mrs. Frank Carter, postmaster Hattie M. Flagg, Manila McLenon, and Gordon Flag; (standing) Myron H. Clemons, Roy W. Mehaffey, Tom Pease, Forrest S. Smith, Orville Hale, Edward C. Burns, Ford Flagg, and Wilbur Blue. (Courtesy of Historic Lake Wales Society and Depot Museum.)

In this 1929 photograph of the post office, the Florida Specialty Shop has opened on the east side of the building. On October 1, 1926, the first city mail delivery was established with Roy Mehaffey and Wilbur Blue as letter carriers. (Courtesy of Max Mayer, Mayers Jewelers.)

The Lake Wales Area Chamber of Commerce erected this billboard in 1925 to raise money for a hotel, "a community enterprise, every citizen a stockholder." When the 10-story Dixie Walesbilt Hotel opened in 1927, the hotel brochure called the skyscraper "an accomplishment of the Chamber of Commerce, [and] a monument to the splendid civic spirit of Lake Wales, which made it possible." (Courtesy of Historic Lake Wales Society and Depot Museum.)

The new Dixie Walesbilt stands on First Street between Stuart Avenue and Park Avenue—a luxury hotel that promised its guests "true Southern hospitality." It featured 100 guest rooms, a ballroom, dining rooms, lounge, laundry, mezzanine promenade, and a "splendid array" of retail shops on the ground floor. According to the hotel brochure, all this was "on a scale befitting not only the community of today, but that of tomorrow." (Courtesy of Max Mayer, Mayers Jewelers.)

The brochure for the new hotel stated, "The top of the hotel is over 300 feet above sea level, or slightly less than Iron Mountain, 2 miles away, which is recognized by the U.S. Geological Survey as the highest point in Florida. The 10-story building has an unobstructed view of beautiful hills and a score of lakes around the city." This 1929 photograph looks north toward Iron Mountain from the top of the hotel. (Courtesy of Historic Lake Wales Society and Depot Museum.)

This late-1920s photograph looks toward the east on Stuart Avenue from Scenic Highway. On the left is the 1917 Scenic Garage and beyond that is the Scenic Theater and Crown Café. The Dixie Walesbilt Hotel towers high in the center; to the right is the Stuart Avenue side of the Rhodesbilt Arcade. The Bullard Building is on the far right. (Courtesy of Polk County Historical Association, Polk County Museum.)

Pictured here is the first board of directors of the town's first bank, the Lake Wales State Bank on Park Avenue. From left to right are Edward Crosland Stuart, an unidentified man, Mr. Sessoms, bank manager Bothwell Hugh Alexander, and G. V. Tillman. (Courtesy of Historic Lake Wales Society and Depot Museum.)

During the height of the great Florida land boom in the mid-1920s, there was so much activity around the train depot at the corner of Scenic Highway and Park Avenue that it caused traffic congestion downtown. Because of this, in 1928, this Atlantic Coast Line Depot was constructed farther south at 325 South Scenic Highway. (Courtesy of Historic Lake Wales Society and Depot Museum.)

Soon after the Atlantic Coast Line Railroad Station was built in 1928, this photograph was taken from the tower of the mission-style Buchanan Automobile Agency, which had been constructed across the street in 1925. The railroad discontinued passenger service to Lake Wales in 1954. Trains no longer stop at the station, which was converted into the Depot Museum in 1976. (Courtesy of Historic Lake Wales Society and Depot Museum.)

From Lake Wales's beginning in 1911 until the summer of 1917 when the city charter passed, the duties of town governance were performed by the Board of Trade (now the Lake Wales Area Chamber of Commerce), the Lake Wales Woman's Club (formerly the Lake Wales Civic League), and the Lake Wales Land Company. The first "city hall" was a room on the second floor of Lake Wales State Bank. In 1928, at the end of the Florida land boom, this new city hall was completed at 152 East Central Avenue. It served the city government from 1928 to 1999. In addition to city commission meetings, the building also housed the fire department (on the far left in this 1929 photograph), the second-floor courthouse, the jail, and the city manager's office—and even housed the library for a time. Now on the National Register of Historic Places, the old city hall has been beautifully restored and serves as the J. D. Alexander Campus of Polk State College. (Courtesy of Historic Lake Wales Society and Depot Museum.)

One of the leading American landscape architects in the early 20th century, Frederick Law Olmsted Jr., completed a street-planting plan for Lake Wales in 1930. Shown here is a page of the Olmsted plan outlining the type of plants that would be used in the landscape design. (Courtesy of Historic Lake Wales Society and Depot Museum.)

Remnants of the plantings that were completed according to Olmsted's design can still be seen on some Lake Wales streets. This photograph looks south on Cypress Gardens Street in the 1940s. Each street had its own identity, and neighborhoods themselves had identities based on types of plantings, such as shade trees, palm trees, or deciduous trees. (Courtesy of Historic Lake Wales Society and Depot Museum.)

The tall clock tower, in the foreground of this 1931 photograph, was created that same year as a gift to the city of Lake Wales by sisters Sarah E. and Emma Y. Kolb. It was placed at Park Avenue and Cypress Garden Lane. The sisters were winter residents of Mountain Lake Estates, 2 miles north of Lake Wales. E. R. Jahna Industries made the bricks by hand that serve as the core of the tower. The surface was covered with coquina rock, and the four clock faces are porcelain. A handsome bronze plaque acknowledging the donors and the completion date also serves as a door to access the interior where the clockworks are found. The clock tower, a town landmark, was moved to the marketplace on Park Avenue in 1972. (Courtesy of Historic Lake Wales Society and Depot Museum.)

Lake Wales Main Street and Historic Lake Wales Society honored the founding fathers with an outdoor mural painted on a building on West Central Avenue in the mid-1990s. The mural portrays, from left to right, C. L. Johnson, G. V. Tillman, A. C. Nydegger (surveying the town in the central picture insert), B. K. Bullard, and E. C. Stuart. The downtown historic district has an ongoing mural project with many other beautiful examples of the town's history and surrounding natural scenery painted on historic buildings. (Courtesy of Historic Lake Wales Society and Depot Museum.)

Three
A Community's Spirit

This photograph was taken in the summer of 1918 when these Lake Wales citizens got together to plant grass in Crystal Park and then enjoyed a meal together. In the early days when the town was very small, its residents gathered at least once a week for church services, followed by a meal—often a picnic like this one. (Courtesy of Historic Lake Wales Society and Depot Museum.)

Lot 4 or 5 overlooking Lake Wales.

Even with the rapid growth of the town, in 1918, most of the land around Lake Wailes would have looked much like this. The man here is standing on town lot 4 or 5 according to the photograph's inscription. From 1915 to 1920, Lake Wales's population more than tripled and continued to be one of the fastest-growing towns in the county until the Depression. (Courtesy of Historic Lake Wales Society and Depot Museum.)

312 Third Street near Crystal Lake, Lake Wales, Florida

Beautiful homes on smooth asphalt roads circling clear lakes were the visual sales tools used by Lake Wales Land Company real estate agents like J. Walker Pope and Joe "Booster" Briggs to sell property during the land boom. The area featured many inviting scenes that could have easily been used in a sales brochure, such as the one in this 1930s photograph taken near Crystal Lake. (Courtesy of Historic Lake Wales Society and Depot Museum.)

Joe "Booster" Briggs earned his nickname as a successful real estate salesman and a tireless, enthusiastic promoter of Lake Wales. Briggs was the first president of the realtors board. He was well known for his energy, quick wit, and lively sense of humor. Friends wanted him to run for political office, but he preferred to stay behind the scenes. Briggs; his wife, Sara Sample Briggs; and their daughters, Alice, Bessie, Louise, and Elsie, moved into their new home on Lakeshore Boulevard across from Lake Wailes in 1915. This 1921 photograph, taken in front of the new Scenic Theater on Stuart Avenue, shows, from left to right, George Robinson, Joe "Booster" Briggs, a large tarpon fish, Maj. J. T. Watkins, an unidentified man, and young William Zipprer, who was employed as a Western Union delivery boy. Someone's bare toes can just be seen hanging down above the second man's head. (Courtesy of Historic Lake Wales Society and Depot Museum.)

Job opportunities in the turpentine industry brought both white and black Americans into Lake Wales to work for the C. L. Johnson and Company turpentine complex, which began operations in 1911. (Courtesy of Historic Lake Wales Society and Depot Museum.)

African Americans played an important role in building Polk County. This 1911 photograph shows a crew working on the road that would become Scenic Highway in front of a newly built store on Starr Lake. The railroad and the highway were laid together. As the railroad progressed, workers were able to bring supplies for both projects by railcar. (Courtesy of Historic Lake Wales Society and Depot Museum.)

Though his name has been lost to history, this teamster was a familiar site around Lake Wales in the late 1920s. At the speed his ox traveled, the flat automobile tires on his homemade dray worked just fine. He lived in the northwest section of Lake Wales, known as "the quarters" in those days. (Courtesy of Historic Lake Wales Society and Depot Museum.)

The men in the foreground wait to board a train at the Lake Wales Station on their way to join the U.S. Army during World War I. From left to right are Emanuel Brown, Shelton King, Joseph Roper, Wade Roper, Sol Bevel, John Pick Taylor, Will Berry, John Butter, Clifford LeFinan, and William Knight. Soldiers from Polk County numbered 1,193 by August of that year. Nearly half of them—575—were African Americans. (Courtesy of Lake Wales Public Library.)

Students and teachers stand in front of Lake Wales's first schoolhouse for African American children. The Lake Wales Land Company donated the land to the school board for this schoolhouse on Washington Avenue and E Street in 1917. (Courtesy of Historic Lake Wales Society and Depot Museum.)

Roosevelt High School was the alma mater of the area's African American students from 1938 through 1968. The school's football team was so successful that it played against junior college teams. The popular Roosevelt High School band played at the football games and drew fans all from all over Lake Wales and beyond. This photograph of Roosevelt students was taken in the mid-1960s. (Courtesy of Historic Lake Wales Society and Depot Museum.)

Jesse Williams and his wife, Anne May, moved to Lake Wales in 1920. He had an outdoor shoe-shine business in the arcade downtown where he charged 10¢ to shine a pair of shoes. He was a well-known celebrity downtown for decades and had nicknames for everyone. Williams was so well respected and loved by Lake Waleans that he received several awards, and the community painted a mural of him on Park Avenue. (Courtesy of Historic Lake Wales Society and Depot Museum.)

The people enjoying a ride in this 1916 "machine " (as automobiles were called in the early 1900s) are unidentified, but Lake Wales pioneer Mary Zipprer recalls that one of the women here was a teacher at the Lake Rosalie school. (Courtesy of Mary Zipprer.)

Jacob Kirch, a building contractor in Indianapolis, Indiana, wanted to visit Florida after seeing advertisements for Lake Wales in the *Indianapolis Star* newspaper. Kirch and his wife, Louisa, brought their family to Florida in March 1914 to see if the area could really be as serenely beautiful and prosperous at the brochure portrayed. (Courtesy of Historic Lake Wales Society and Depot Museum.)

After buying 23 acres on Starr Lake, the Kirch family did what was typical of many early settlers in the area: they set up a tent camp to live in while they built their house. Pictured here in 1914 are the Kirches' recently arrived neighbors, Mr. Bouie (left) and Mr. Brown. (Courtesy of Historic Lake Wales Society and Depot Museum.)

In this 1914 photograph, Jacob Kirch and two of his sons, unidentified, stand in front of the first building on their Starr Lake property. Once they were able to sleep in the frame structure, the Kirches used the tents behind them for storage. Theirs was the first home on Starr Lake. (Courtesy of Historic Lake Wales Society and Depot Museum.)

Like most settlers from the North, the Kirch family wanted to escape the winters and build a little paradise with a citrus grove that would help support them. When they arrived in March 1914, the scent of orange blossoms filled the air and seemed to be "a bit of heaven after the snows and ice in the North," according to Hazel Kirch. From left to right are Marie and Hazel Kirch. (Courtesy of Historic Lake Wales Society and Depot Museum.)

Jacob Kirch bought 3 acres to build his home on and 20 acres across the sand road that would become Scenic Highway. Like his neighbor P. K. Huey, shown here with a papaya tree, Kirch planted tropical fruit trees on his residential acres and a citrus grove on the other 20 acres. (Courtesy of Historic Lake Wales Society and Depot Museum.)

With Starr Lake and their home in the background, the Kirch family poses in this 1917 photograph. Seen here from left to right are (first row) George, Mary Louise, Loretta, Sylvester, Arthur, and Jacob; (second row) Cecilia, Marie, Louisa, and Hazel Kirch. (Courtesy of Historic Lake Wales Society and Depot Museum.)

64

Arthur Kirch holds a medium-sized specimen of alligator that had probably been swimming in Starr Lake shortly before this photograph was taken. Fried alligator tail is a delicacy to Floridians. According to Everglades National Park, the largest alligator ever recorded in Florida was 17 feet, 5 inches long. (Courtesy of Historic Lake Wales Society and Depot Museum.)

Fred Wippel, a friend of the Kirch boys, accompanied the family to Florida and lived with them for a time while their house was being built. Shown here on horseback, he carries a gun to hunt game, which was plentiful in the area. (Courtesy of Historic Lake Wales Society and Depot Museum.)

Hunting was a hobby, a means of gathering food for settlers, and sometimes a preventive measure to protect children, pets, and livestock. This bobcat, or "wildcat," is the catch of the day in this 1915 photograph. From left to right are an unidentified dog, George, Sylvester, and Arthur Kirch, and Fred Wippel with Cap the dog. (Courtesy of Historic Lake Wales Society and Depot Museum.)

Marie and Hazel Kirch are playing with their pet raccoon in this 1916 photograph. Jacob Kirch was interested in wildlife and kept a small zoo, including an alligator in a tank and caged raccoons, foxes, bobcats, and a rattlesnake. The Kirch family homestead was a popular stop for Northern visitors interested in buying land in the Lake Wales area. Jacob served his guests watermelon, and they were usually fascinated by the Kirches' zoo. (Courtesy of Historic Lake Wales Society and Depot Museum.)

Steve Ross, Hazel Kirch, Marie Kirch, Arthur Kirch, Fred Wippel, and Mrs. Ingham are enjoying a swim in Starr Lake in this 1916 photograph. Just a few years earlier, the short bathing suits these women are wearing might have been scandalous, but they were accepted by all but the most conservative in 1916. (Courtesy of Historic Lake Wales Society and Depot Museum.)

Jacob and Louisa Kirch, pictured here in the 1930s, are enjoying the "little paradise" they created in the backyard of their home on Starr Lake. Both of them passed away at the homestead—Jacob at the age of 95 and Louisa at the age of 96. (Courtesy of Historic Lake Wales Society and Depot Museum.)

The Woman's Club held its first meeting on May 26, 1914, and the club quickly became the foundation of the town's social life. After Crystal Lodge was built for the club in 1920, the women started the town's first public library there. Past club presidents shown here in 1938 are, from left to right, (first row) Mrs. Pallas Gum, Mrs. R. N. Jones, Mrs. H. H. True, Mrs. J. L. Pennington, Mrs. Buford Gum, and Mrs. J. W. Shrigley; (second row) Mrs. R. B. Buchanan, Mrs. H. S. Norman, Mrs. W. L. Ellis, Mrs. B. K. Bullard, Mrs. L. A. Yarnell, Mrs. J. B. Stritmater, and Mrs. Milo M. Ebert. (Courtesy of Historic Lake Wales Society and Depot Museum.)

Two Lake Wales fire stations were combined when this modern firehouse was built in March 1917. The firefighting equipment was moved from the smaller stations to this one located on Scenic Highway south of the Florida Ice and Power Company building. The firefighters were all volunteers, and nearly every man in the community participated. (Courtesy of Historic Lake Wales Society and Depot Museum.)

IRON MOUNTAIN, LAKE WALES, FLA., HIGHEST POINT IN STATE

On February 24, 1883, Robert J. Ruth acquired 1,400 acres of land near Iron Mountain, the highest point in Florida, shown in the distance in this early-1920s photograph. The heavily forested property lay unchanged until it was inherited by Fredrick Ruth. After buying up surrounding properties, in 1914 he established Mountain Lake Estates, which is now on the National Register of Historic Places. (Courtesy of Historic Lake Wales Society and Depot Museum.)

The Mountain Lake Golf Course is an 18-hole championship course along the west side of Mountain Lake. Well-known links designer Seth Raynor worked with Frederick Law Olmsted Jr. to create the course in the 1920s. This photograph by A. L. Alexander shows golfers on the 18th tee. (Courtesy of Historic Lake Wales Society and Depot Museum.)

In 1923, at the height of the Florida land boom, Irwin A. Yarnell and his wife, Josephine Sullivan Yarnell, built this mansion in Highland Park Village. The castle was named Casa de Josefina in honor of Josephine. Having made their money in real estate, the Yarnells lost their lavish lifestyle when the land boom went bust in the late 1920s. (Courtesy of Historic Lake Wales Society and Depot Museum.)

In this 1926 photograph, August Hecksher and Mrs. Hecksher stand by a monument erected in gratitude for August's donation of playground equipment to the park beside Lake Wailes. The marker was paid for with the pennies contributed by over a thousand children. The Lake Wailes Pavilion stands in the background. (Courtesy of Historic Lake Wales Society and Depot Museum.)

Arthur L. Alexander was born in 1856. At the age of 18 he became interested in photography, which was still a primitive art. He had to learn to prepare his own photographic plates and silver his own paper for the images he created. In 1915, poor health brought Alexander and his wife, Stella, to Lake Wales from Ann Arbor, Michigan. He had already made a name for himself in Michigan and quickly became famous in Florida for the artistry of his work. His first studio was on Park Avenue downtown where he frequently walked the soft sand streets in his wooden shoes, a remnant of his Dutch heritage. As a lifelong professional photographer, he experimented over the years with different processes, unusual angles, and lighting. He also experimented with self-portraits like the one above. (Courtesy of Historic Lake Wales Society and Depot Museum.)

Alexander was a man of many talents. In addition to being a photographer, he was an accomplished musician who played many instruments, including the flute, banjo, fiddle, and violin. The bird sitting on his flute in this self-portrait was also in some of his other photographs. (Courtesy of Historic Lake Wales Society and Depot Museum.)

This Alexander image shows his wife, Stella, handling a snake. Stella was the subject of many of his pictures, and she helped him in his studio. One of his artistic interests was photographing nature, and many of his bird photographs are preserved today in the Lake Wales Depot Museum. (Courtesy of Historic Lake Wales Society and Depot Museum.)

Stella and A. L. Alexander are seen here studying film in the light from the window of their first home on Park Avenue. Stella was active in several community organizations. She was elected chairwoman of the new local Red Cross unit and was also a charter member of the Lake Wales Woman's Club. (Courtesy of Historic Lake Wales Society and Depot Museum.)

This silhouette of two mules with Lake Wailes sparkling in the background was taken by A. L. Alexander. Most of his later photographs are stamped with his name in raised letters as seen in the bottom left corner here. (Courtesy of Historic Lake Wales Society and Depot Museum.)

"The dream of an artist come true" was the headline when Alexander's home, pictured here soon after completion in 1923, made national headlines. In 1922, F. W. Haemmel, a New York artist, had painted the picture of a home he had seen in a dream. The painting won a contest and was published on the cover of *House Beautiful*. Alexander saw the magazine cover and was intrigued by the A-frame design, which was both unusual at the time and in the shape of his first and last initials. He created the plans for the structure and had it built in front of his home on Scenic Highway to use as a studio. Quite by accident, F. W. Haemmel happened to be driving on Scenic Highway the next year and was struck by the sight of his vision, materialized. Haemmel went inside to meet the builder, and the two artists became friends. Several articles were written about this unusual chance meeting of two great minds with a single vision. (Courtesy of Historic Lake Wales Society and Depot Museum.)

Alexander frequently used his unusual studio or the long, curving steps to his home behind the studio as backdrops for his formal photographs. In this early 1920s portrait, one of the first orchestras in Lake Wales poses in front of the studio. (Courtesy of Historic Lake Wales Society and Depot Museum.)

Along with his musical talent and photography, Alexander's artistry included sculpture—as seen in this image of a whimsical dinosaur he crafted. He also painted, using several different mediums, and was even a poet. (Courtesy of Historic Lake Wales Society and Depot Museum.)

A. L. Alexander and Stella are pictured here in their later years walking on a path through the Bok Tower Gardens. Alexander had become good friends with some of the people at Mountain Lake Estates, including Roger Babson and Edward W. Bok. (Courtesy of Historic Lake Wales Society and Depot Museum.)

Always a dapper dresser, Alexander was considered a unique person with a quirky personality by Lake Waleans. He captured the look, the feel, and the visual story of the town in its infancy. He died in 1947 at the age of 91. (Courtesy of Historic Lake Wales Society and Depot Museum.)

Four
BUSINESS AND INDUSTRY

Transportation lines are the arteries that feed the growth of all towns. The phenomenal growth Lake Wales experienced in the early years would not have been possible without the arrival of the railroad, which helped business thrive and created employment opportunities. This early 1920s photograph of an Atlantic Coast Line train looks west toward Park Avenue. (Courtesy of Historic Lake Wales Society and Depot Museum.)

With trains arriving daily carrying passengers and cargo, the railroad affected every business in town. This boxcar arrived in Lake Wales around 1920 and contained a "solid carload of shoes for Friedlander, Inc., a direct shipment from Boston factories," according to the banner. (Courtesy of Historic Lake Wales Society and Depot Museum.)

The cattle industry has been important to the economy of the Lake Wales area since the 1800s. William David Crews, a pioneer cattleman, is pictured here in 1976 at the age of 88. Born in 1888, he and his family hunted wild, free-range cattle, which did not require owning much land. He bought his first property in 1922 west of Lake Wales and planted it in citrus groves. (Courtesy of Historic Lake Wales Society and Depot Museum.)

In November 1919, August Hecksher of New York City and Mountain Lake Estates bought over 4,600 acres of land north of Lake Wales from B. K. Bullard of the Lake Wales Land Company. Hecksher named it Templetown for the Temple orange groves he planted there. These vast groves were the largest in Florida at the time and stretched for miles to the east of Iron Mountain. The groves were nearly destroyed by a hard freeze in 1934, and some of the land was sold afterwards. Fires destroyed more acres a few years later. Nonetheless, today Mammoth Grove continues as one of the oldest commercial groves in Florida, and a substantial number of its trees are the same ones planted in 1900 by Hecksher's Florida Highlands Citrus Company. (Courtesy of Historic Lake Wales Society and Depot Museum.)

The Florida Highlands Citrus Corporation planted orange and grapefruit with scientific cultivation practices and hired expert horticulturalists. (Courtesy of Alcoma Caretakers, LLC.)

The sale of the majority of Mammoth Grove to Arch R. Updike in 1941 was the largest citrus grove transaction in Florida history at the time. The company became Alcoma Properties and included over 2,500 acres of citrus groves, a large packing plant, and 80 dwellings. The Alcoma machine sheds and cultivation equipment are shown in this early-1940s photograph. (Courtesy of Alcoma Caretakers, LLC.)

Many people moved to Florida with a goal of acquiring a few acres for citrus groves to help support the family. The family usually built their home in the grove. Here Hazel Kirch stands in the Kirch family's newly planted grove near Starr Lake in 1915. (Courtesy of Historic Lake Wales Society and Depot Museum.)

Citrus grove caretakers serviced both corporate-owned groves and family groves. Caretakers would tend the groves, including harvesting crops, trimming trees, mowing, and later fertilizing, spraying, and irrigating. (Courtesy of Historic Lake Wales Society and Depot Museum.)

Irrigation was a problem for all agriculture on the sandy hills of the ridge. This photograph, taken before 1920, shows mules waiting to pull an irrigation water tank with a broken axle on agricultural land on top of Iron Mountain. (Courtesy of Historic Lake Wales Society and Depot Museum.)

Harold and Mary Beth Struthers are picture here in 1938. Harold was a beekeeper from Winter Haven, Florida. Mary Beth was the granddaughter of L. A. Coblentz and daughter of Julia Waller, both beekeepers. After meeting at a bee convention in Minnesota, Harold and Mary Beth were married and moved to Lake Wales to open the Struthers Honey House. (Courtesy of Struthers Honey Company.)

Mary Beth and Harold Struthers moved to Lake Wales in 1935 and started Struthers Honey at the corner of Rose Terrace and Hesperides Road. The company, owned today by their son, fourth-generation beekeeper Alden Struthers, and his wife, Lotta Kay, sells honey on the honor system. This 1960s photograph shows the Struthers Honey House when Highway 60 was only a two-lane country road. (Courtesy of Struthers Honey Company.)

Emmanuel and Olinda Ekeland moved to Starr Lake in 1915 with their children, Gudrun and Tarolf. Soon after moving to the area, the Ekelands built this two-story building on what would become Scenic Highway with a general store downstairs and their living quarters upstairs. (Courtesy of Historic Lake Wales Society and Depot Museum.)

Dr. William M. Hardman (1932–2010) practiced medicine in his hometown of Lake Wales for 42 years. A graduate of Lake Wales High School class of 1950, he attended the University of Florida and Emory University School of Medicine. Returning home in 1965, Bill was the first medical specialist of any kind in Lake Wales. During his career in obstetrics and gynecology, he delivered more than 6,000 babies. Dr. Hardman was honored as the 2009 Lake Wales Pioneer of the Year.

The Log Cabin Tea Room and Inn was built on Stuart Avenue west of Scenic Highway in 1926. Blanche Rinaldi and her daughter, Elizabeth, ran the tearoom and inn while her husband operated the Polk County Supply Company. (Courtesy of Historic Lake Wales Society and Depot Museum.)

Sherman's Texaco Garage was located at Scenic Highway and Polk Avenue in 1929. The town's first automobile dealer was F. C. Buchanan of the Briscoe Motor Corporation. He sold a five-passenger touring Briscoe for $1,285. (Courtesy of Historic Lake Wales Society and Depot Museum.)

Phosphate mining created a boom in Polk County starting in 1889 and provided jobs for people from all around the county. Sand mining began near Lake Wales in the 1940s and is still important to the economy today. (Courtesy of Historic Lake Wales Society and Depot Museum.)

This 1920s photograph shows one of the earliest model homes in Lake Wales, the Hoops model home at Golfview. It was built by Walter W. Hoops Architects and Builders. (Courtesy of Historic Lake Wales Society and Depot Museum.)

The Lake Wales Tourist Club began in 1920 and attracted thousands of people to Lake Wales over the years. The tourist club is located near Lake Wailes on Lakeshore Boulevard. (Courtesy of Historic Lake Wales Society and Depot Museum.)

The hospitality, tourism, and travel industry has been big business in Florida since the early 1900s. The elegant Hotel Wales is shown here in the early 1920s. (Courtesy of Thalia Heirs.)

Small, independent businesses downtown have always been the heart of the Lake Wales community. This 1920s photograph shows the business and professional directory that was located on Park Avenue. (Courtesy of Library Public Library.)

Five
COMMUNITY RECREATION

These 1930s Lake Wales hunters have killed a Florida black bear, which were common in those days. The hunters brought their dogs and their catch to the home of photographer A. L. Alexander to have this picture taken. (Courtesy of Historic Lake Wales Society and Depot Museum.)

The Lake Wales area was known by local Native Americans as a good hunting ground long before settlers came in 1911 and called it a sportsman's paradise. Many ancient arrowheads and several dugout canoes have been found in the area. The ridge's range of habitats is suited to a variety of game such as quail, turkey, deer, rabbit, raccoon, fox, alligator, bears, bobcat, and wild hog. Even cattle were wild game in the early 1900s. The successful hunters shown here with their bird dogs have killed too many bobwhite quail to count. Shown from left to right in this 1920s photograph are Frank Scaggs, Bill Scaggs, Bob Lennon, and Alan Meeks. (Courtesy of Historic Lake Wales Society and Depot Museum.)

Lake Wales High School had an undefeated football team in 1926. Seen here from left to right are (first row) Leland Blackburn, Gerald Clarke, Charles Kegeris, Tom Campbell, Wint Aiken, Earl Green, and Marton Roberts; (second row) coach Hugh Harrison, Elory Lloyd, Walter Woolfolk, Hubert White, and Dawson Walker. This was the third team in Lake Wales to finish its season without a single defeat. The 1926 team had four men with all-state honors and made the community football-conscious through all the subsequent years. Not pictured here but on the team were Bob Huffman (first team All-State), J. W. Thornhill, and Bill Zipprer. Football, baseball, golf, basketball, and soccer are all popular sports in Lake Wales today. (Courtesy of Historic Lake Wales Society and Depot Museum.)

The Tourist and Shuffleboard Club was located in Crystal Lake Park near downtown Lake Wales. The sport drew large crowds from the mid-1920s through the 1930s. (Courtesy of Historic Lake Wales Society and Depot Museum.)

In the 1920s, this group of tourists from Miami, Florida, arrived in Lake Wales. The "Goodwill Party" visited the Lake Wales Area Chamber of Commerce and toured the sites, including Iron Mountain, seen in this photograph. (Courtesy of Historic Lake Wales Society and Depot Museum.)

Sometimes all that the town's residents needed for recreation was a simple walk around Crystal Lake or Lake Wailes, as these two unidentified sisters demonstrate in this 1920s photograph. (Courtesy of Max Mayers, Mayers Jewelers.)

Along with most of the men in town, "Booster" Briggs was an avid fisherman. He is shown on the left here with an unidentified man. The townspeople found a bounty of fish in the numerous local lakes. (Courtesy of Historic Lake Wales Society and Depot Museum.)

This 1922 photograph shows the town's first high school orchestra. Seated from left to right are (first row) Guy Pope, Marie Kirch, Norma Whitner, Eleanor Pooser, and Opal Sholtz; (second row) Jack Townsend, Elmer Hulquist, Roma Fraser, Charles Donoho, and director Fred Sholtz. (Courtesy of Historic Lake Wales Society and Depot Museum.)

The members of a 1920s Lake Wales orchestra pose for A. L. Alexander in front of his A-frame studio on Scenic Highway. (Courtesy of Historic Lake Wales Society and Depot Museum.)

Taking a Sunday afternoon drive on the "velvet" roads of Lake Wales was a popular pastime. J. A. Caldwell sits in his automobile in front of his home in this early 1930s photograph. This house, the first built in Lake Wales, was later torn down. (Courtesy of Historic Lake Wales Society and Depot Museum.)

This 1936 aerial photograph shows the newly completed Lake Wales Athletic Park on the shore of Lake Wailes. The field became the training camp of the minor league Milwaukee Brewers and was later called Legion Field. (Courtesy of Historic Lake Wales Society and Depot Museum.)

These workers have just completed constructing the bleachers at the Lake Wales Athletic Park on Lake Wailes in 1936. (Courtesy of Historic Lake Wales Society and Depot Museum.)

Shown here in this 1936 photograph are officials of the Milwaukee Brewers, which played in the American Association. From left to right, they are club president Henry Bendinger, field manager Allen Sothoron, and business manager Louis Nahin. The Brewers' new training camp opened in 1936. (Courtesy of Historic Lake Wales Society and Depot Museum.)

Pictured here are the members of the 1936 Milwaukee Brewers team during their first practice at the Lake Wales spring training camp. (Courtesy of Historic Lake Wales Society and Depot Museum.)

Over 1,200 fans attended the first Milwaukee Brewers game in Lake Wales in 1936. (Courtesy of Historic Lake Wales Society and Depot Museum.)

In this 1924 photograph, children play on the shore of Crystal Lake while adults are gathered on Park Avenue near the First Presbyterian Church on the right. The Associated Reformed Presbyterian Church, as it was called in 1911, first met in the newly built Hotel Wales. The first church service in the sanctuary seen here was held on March 9, 1913. E. C. Stuart donated the lot and the building, saying that every town needed a church. Today a large Presbyterian church complex stands at this location. In the far distance, center, the dome of the 1923 First Baptist Church can be seen above the trees. (Courtesy of Max Mayer, Mayers Jewelers.)

359 Baptist Church, Lake Wales, Fla.

G. V. Tillman helped found Lake Wales's Baptist church. It held its first organizational meeting July 23, 1916, and the church covenant was adopted. O. G. Tillman, G. V.'s son, was elected church secretary; H. M. Fraser became the superintendent of Sunday schools; and Mrs. J. F. Townsend was the organist. Services were held in the Masonic Lodge, which was located upstairs in the J. T. Rhodes Building on Park Avenue. In 1923, the congregation built this First Baptist Church at 338 East Central Avenue. Covered in buff-colored brick, the building was added to the National Register of Historic Places on August 31, 1990. (Courtesy of Max Mayer, Mayers Jewelers.)

Discussions about building a Catholic church in Lake Wales began early in 1920. The original land donated by the Lake Wales Land Company as a church site was later traded for a larger site on the corner of Hesperides Road (now Highway 60) and Eleventh Street. The only Catholic church in the Lake Wales area at the time was the St. Anne Shrine, 6 miles east of town. Josephine Yarnell from Crooked Lake was given the honor of naming the first Catholic church in Lake Wales. She called it Spiritus Sancti, or Church of the Holy Spirit. The new church is pictured here soon after it was built in 1927. The architecture is one the most beautiful examples of Spanish mission style in Florida. The building is on the National Register of Historic Places and is now the home of the Lake Wales Arts Center. (Courtesy of Max Mayer, Mayers Jewelers.)

In 1920, the City of Lake Wales built an 18-hole Municipal Golf Course 2 miles east of town on Hesperides Road. This was the entrance to the clubhouse, which can be seen in the distance on the left. (Courtesy of Historic Lake Wales Society and Depot Museum.)

According to a *Lake Wales News* article covering the third anniversary of the Municipal Golf Course, the course had quickly become "known all over the state as right at the top of golf courses" and was bringing the city "much publicity from out of state." The golf course is now part of the Lake Wales Country Club. (Courtesy of Historic Lake Wales Society and Depot Museum.)

This 1920s pastoral scene was photographed on Lake Caloosa, now known as Crooked Lake, near Lake Wales. A citrus grove can be seen in the distance across the lake. Boating is still a popular recreation in Lake Wales. (Courtesy of Historic Lake Wales Society and Depot Museum.)

Six
AREA ATTRACTIONS

Born in 1863, Edward William Bok came to America with his parents from the Netherlands at the age of six. He became a Pulitzer Prize–winning author, editor of *Ladies Home Journal* for over 30 years, and a winter resident of the exclusive Mountain Lake Estates near Lake Wales. (Courtesy of Historic Lake Wales Society and Depot Museum.)

Edward Bok bought 14 acres at the top of Iron Mountain in the spring of 1922 to create a bird sanctuary in memory of his grandparents. Bok is feeding a nightingale in the garden. (Courtesy of Historic Lake Wales Society and Depot Museum.)

Edward Bok later purchased an additional 46 acres to create the Mountain Lake Sanctuary. Mary Louise Curtis Bok and Edward Bok look on as Maj. Harry M. Nornabell, center, breaks ground for the tower in 1927. Nornabell was the first director of the sanctuary. (Courtesy of Florida State Archives.)

Landscape architect Frederick Law Olmsted Jr. designed the sanctuary gardens. The irrigation alone took a year to install, and thousands of truckloads of soil were brought in for the gardens, which included hundreds of large live oaks and sabal palms, thousands of azaleas, and hundreds of magnolias and gardenias. One of the tall palm trees is being planted in this photograph. (Courtesy of Historic Lake Wales Society and Depot Museum.)

A team of grove workers are planting a citrus tree in the Mountain Lake Estates grove on high ground near the Mountain Lake Sanctuary in this 1928 photograph. Bok's Singing Tower can be seen under construction in the distance on the right. (Courtesy of Historic Lake Wales Society and Depot Museum.)

Architect Milton Medary designed the sanctuary's 205-foot tower with 4-foot-thick brick walls supported by a steel frame. The first 150 feet of the tower is faced with pink coquina stone. The base, buttresses, and top of the tower are covered with marble. (Courtesy of Historic Lake Wales Society and Depot Museum.)

Two 35,000-gallon water tanks located halfway up the tower once served the complex irrigation system for the sanctuary's gardens. More acreage has been acquired over the years by the sanctuary to encompass over 700 acres in 2010, including 220 acres acquired in 2009. (Courtesy of Historic Lake Wales Society and Depot Museum.)

The bells of the Singing Tower carillon took a year to cast and tune by the John Taylor Bellfounders in Loughborough, England. Cast from the finest bronze, an alloy of best selected copper and tin, the largest bell, shown in this 1928 picture before it left England, weighs 23,000 pounds and measures 8.5 feet wide at its base. The smallest bell weighs 17 pounds and is only 7 inches wide at its base. The bells are played from a keyboard called a clavier by a carillonneur who uses his closed hands to play large keys and his feet to play the pedal board. The carillon has 60 bells with a range of five octaves. The total weight of all the bells is 123,477 pounds. This carillon is considered one of the finest in the world. (Courtesy of Historic Lake Wales Society and Depot Museum.)

In this 1928 photograph, the largest bell of the carillon is unloaded from a trailer and swung into the unfinished side of the tower on the left. Once inside, the bell was then hoisted to the top of the tower by an electric crane designed by the tower's architect, Milton Medary. (Courtesy of Historic Lake Wales Society and Depot Museum.)

Anton Brees, born in Antwerp, Belgium, on September 14, 1897, became one of the world's most famous carillonneurs during his lifetime. He was the first carillonneur at the Singing Tower and performed at the gardens until his death in 1967. (Courtesy of Historic Lake Wales Society and Depot Museum.)

High in the tower, screened behind intricately carved tile grills (shown in the background here), are the 60 bronze carillon bells. Created by J. H. Dulles Allen of Enfield Pottery and Tileworks near Philadelphia, the massive grills provide the openings in the bell chamber that allow the bells to fill the sanctuary gardens with music. Located at the highest elevation of Iron Mountain, the tower is the centerpiece of the Olmsted-designed gardens. Construction on the tower itself began in 1927 and was completed for the gardens's dedication in 1929. The tower is 51 foot square at its base and changes at 150 feet high to an octagon with sides that include sculptures designed by Lee Lawrie. (Courtesy of Historic Lake Wales Society and Depot Museum.)

Inside the Singing Tower on the ground floor is the Founder's Room. The upper levels contain mechanical equipment and once held water tanks for the irrigation system. Level two contains the Chao Research Center, which house the archives. The Anton Brees Carillon Library is on level five, and the carillon bells are housed on level seven. (Courtesy of Historic Lake Wales Society and Depot Museum.)

On the day that the Mountain Lake Sanctuary and Singing Tower were to be dedicated, February 1, 1929, all the roads leading up to Iron Mountain were clogged with cars, bumper to bumper for miles around. This photograph was taken from the sanctuary parking lot looking toward the tower. (Courtesy of Historic Lake Wales Society and Depot Museum.)

On February 1, 1929, U.S. president Calvin Coolidge dedicated the sanctuary and tower. Edward Bok presented them as a gift to the American people in gratitude for the opportunity that they had given him. On the speaker stand that day were, from left to right, Mary Bok, Florida governor Doyle E. Carlton, Grace Coolidge, President Coolidge, Edward Bok, and Nell Ray Carlton. In his eloquent address, President Coolidge said, "In appreciation of the munificent generosity which is here exhibited, in my capacity as President of the United States, I hereby dedicate the Mountain Lake Sanctuary and its Singing Tower and present them for visitation to the American people." The Singing Tower quickly became one of Florida's most popular tourist attractions. (Courtesy of Historic Lake Wales Society and Depot Museum.)

This photograph shows a small section of the crowds that attended the tower's dedication in 1929. Thousands of visitors each year have come from all over the world to hear the music from Bok's carillon and enjoy the serenity of the historic landscape gardens. (Courtesy of Historic Lake Wales Society and Depot Museum.)

Pausing for a formal photograph on the day of dedication in 1929 are, from left to right, Grace Coolidge, President Coolidge, Mary Bok, and Edward Bok. Bok married Mary L. Curtis in 1896. She encouraged his love of music. (Courtesy of Historic Lake Wales Society and Depot Museum.)

Seen in the center of this 1941 photograph, Maj. Harry Nornabell, wearing a suit, was the first director of Mountain Lake Sanctuary. He invited Florida Seminole tribe members to camp on Iron Mountain in recognition of the tribe's former worship place at the top of the mountain. (Courtesy of Bok Tower Gardens.)

Seminoles gather at the base of the tower in front of a massive sundial by sculptor Lee Lawrie. The sundial, a block of marble 7-by-9 feet wide and several inches thick, was installed on October 26, 1928, as the tower neared completion. It covers the large opening used to install the bells. (Courtesy of Bok Tower Gardens.)

The Singing Tower carillon and the botanical gardens were designed and created by international master artisans of the day. Hundreds of laborers worked for more than seven years to complete what Edward W. Bok called "America's Taj Mahal." The tower is surrounded by a 15-foot moat that serves as a koi pond, and a pool on the north side of the tower reflects the tower's image. Bok died in Mountain Lake Estates in 1930, just one year after the sanctuary was dedicated. He is buried at the base of the Singing Tower he loved. He lived by his grandmother's advice to "make you the world a bit better or more beautiful because you have lived in it." The sanctuary is listed on the National Register of Historic Places as a National Landmark. Originally known as Mountain Lake Sanctuary and Singing Tower, the sanctuary was later renamed Bok Tower Gardens in honor of Edward W. Bok. (Courtesy of Bok Tower Gardens.)

Natural beauty was the original attraction for the founding fathers' investment in the new town, and preserving it became part of the town plan. Since 1911, tourists and people seeking a friendly small town to call home have found Lake Wales to be a great destination. (Courtesy of Max Mayer, Mayers Jewelers.)

As a gift to the city, the Lake Wales Land Company built this pavilion on Lake Wailes in 1914 at the end of Central Avenue. The beach house had dressing rooms for gentlemen on one side and ladies on the other. The company later built tennis courts and a boathouse at the location. (Courtesy of Historic Lake Wales Society and Depot Museum.)

When the new pavilion opened on Lake Wailes, the public beach behind it replaced all the old favorite swimming holes on other lakes, even the most popular one, nearby Crystal Lake. This photograph of unidentified bathers was taken in the 1920s. (Courtesy of Historic Lake Wales Society and Depot Museum.)

Shown here is a diving competition at the Lake Wailes Pavilion in the 1920s. Citrus groves can be seen in the distance on the left, and the large, two-story house across the lake on the right is the B. K. Bullard home. (Courtesy of Max Mayer, Mayers Jewelers.)

Armistice Day, the end of the World War I on November 11, 1918, was celebrated on the shores of Lake Wailes. The town mayor declared a holiday, and children were dismissed from school. A spontaneous parade came together with children carrying the American flag through the streets downtown. (Courtesy of Max Mayer, Mayers Jewelers.)

A new pavilion was built by the city in 1927 at a cost of $17,000. It was located at the end of Park Avenue on the shore of Lake Wailes. The tall stone monument on the right in the foreground is a war memorial that was later moved in front of city hall. (Courtesy of Historic Lake Wales Society and Depot Museum.)

370 Pavilion in Lake Wales, Florida

The pavilion saw activity throughout the year with dances, swimming, fishing, water skiing, sailing, and motorboat races. The elegant building was the center of social activities until it was demolished in 1974. The pavilion was commemorated on an outdoor mural in Historic Downtown Lake Wales in 2008. (Courtesy of Max Mayer, Mayers Jewelers.)

The 1916 railroad station (now called the "Yellow Depot") at the center of this photograph was restored and relocated to the historic park on Scenic Highway in 1994. (Courtesy of Historic Lake Wales Society and Depot Museum.)

St. Anne Shrine is located 6 miles east of Lake Wales off Highway 60. It was the first Catholic church in Lake Wales and was built by French Catholics from Canada and the U.S. Northeast in 1920. (Courtesy of Historic Lake Wales Society and Depot Museum.)

The St. Anne Shrine complex featured a biblical museum (shown here in 1921); a small, ornately decorated church; Holy Relics; and many ornate statuary and monuments in the gardens, in the small lake, and spread along nature trails through the surrounding woods. (Courtesy of Historic Lake Wales Society and Depot Museum.)

Pilgrimages were made to the St. Anne Shrine from across America with over 75,000 visitors in one year. After the Holy Spirit Church was established in Lake Wales, the shrine became a mission. It was de-sanctified in the 1950s, and most of the shrine was removed. A few historical traces remain. (Courtesy of Historic Lake Wales Society and Depot Museum.)

This sign sat at the famous free Lake Wales attraction called Spook Hill for many years. Tourists and locals alike have enjoyed stopping their cars and watching them roll uphill while in neutral, pulled by invisible forces that defy the laws of gravity. (Courtesy of Florida State Archives.)

SPOOK HILL

THE LEGEND OF SPOOK HILL

MANY YEARS AGO AN INDIAN VILLAGE ON LAKE WALES WAS PLAGUED BY RAIDS OF A HUGE GATOR. THE CHIEF, A GREAT WARRIOR, KILLED THE GATOR IN A BATTLE THAT CREATED A SMALL LAKE. THE CHIEF WAS BURIED ON THE NORTH SIDE. PIONEER MAIL RIDERS FIRST DISCOVERED THEIR HORSES LABORING DOWN HILL, THUS NAMING IT "SPOOK HILL". WHEN THE ROAD WAS PAVED, CARS COASTED UP HILL. IS THIS THE GATOR SEEKING REVENGE, OR IS THE CHIEF STILL TRYING TO PROTECT HIS LAND???

STOP ON WHITE LINE, TAKE YOUR CAR OUT OF GEAR, AND LET IT ROLL BACK.

Spook Hill, located a few blocks from the national historic district, is a mystery of nature. Word of mouth about the gravity hill spread when citrus workers driving their wagons were surprised to find their mule teams struggling downhill with a load. (Courtesy of Historic Lake Wales Society and Depot Museum.)

In the boom days of the 1920s, Carl and Bertha Hinshaw Sr. moved to the quiet community of Starr Lake to be near Bertha's aging parents. Carl Hinshaw is shown here in a 1920s photograph. (Courtesy of Chalet Suzanne Restaurant and Inn.)

Bertha Hinshaw needed to support her two young children single-handedly after Carl Hinshaw Sr. passed away in 1931. Bertha is shown in the center here between two unidentified people as they stand on a walkway near Lake Suzanne. (Courtesy of Chalet Suzanne Restaurant and Inn.)

Bertha Hinshaw started a restaurant, Suzanne's Chalet, named after her only daughter. The name was permanently changed to Chalet Suzanne some years later. The roof on the screen room in this photograph became the roof of the dining room, except that now it was two stories up. (Courtesy of Chalet Suzanne Restaurant and Inn.)

The charming building on the left was the original home of Carl and Bertha Hinshaw Sr. in the 1920s. In 1931, the home was converted into the office for the Chalet Suzanne Country Inn. (Courtesy of Chalet Suzanne Restaurant and Inn.)

In the early 1930s, Duncan Hines visited Chalet Suzanne and sent postcards to all his friends and family telling them how much he enjoyed the food. Pictured here in the Chalet Suzanne dining room are, from left to right, an unidentified man and woman, Bertha Hinshaw, Duncan Hines, and an unidentified woman. (Courtesy of Chalet Suzanne Restaurant and Inn.)

Taken on the Hinshaw property in 1925, this photograph shows, from left to right, (seated) Bertha Hinshaw holding Carl Hinshaw Jr. and Bertha's daughter Suzanne Hinshaw. The others in the photograph are unidentified. (Courtesy of Chalet Suzanne Restaurant and Inn.)

Each of the of the Chalet Suzanne Country Inn cottages has a different quaint design. The interior of one of the unique guest rooms shows some of the intricate design and antiques collected by Bertha Hinshaw. (Courtesy of Chalet Suzanne Restaurant and Inn.)

The Chalet Suzanne Restaurant began having ski shows in the 1940s, and they continued through the 1960s. In this 1940s photograph, Carl and Vita Hinshaw are putting on a ski show with the restaurant's cook driving the boat. (Courtesy of Chalet Suzanne Restaurant and Inn.)

Guests of the inn in the 1930s were transported to Bok Tower Gardens by horse-drawn carriage. The gardens were about an hour's drive over 2 miles of scenic roads. (Courtesy of Chalet Suzanne Restaurant and Inn.)

After returning from a trip to India, Bertha and her son, Carl Hinshaw Jr., built the *Indian Dhow*, the paddleboat seen in the foreground of this photograph. The *Indian Dhow* was used as a party boat for cruising the shores of Lake Suzanne and was featured on the cover of *Life Magazine* in the 1950s. Bertha made many trips abroad and always brought back unusual decorative items to adorn the Chalet Suzanne. Her eclectic collection can be seen all around the chalet. The most outstanding are the lights. Her collection of hundreds of colorful lamps, sconces, swag lamps, and a variety of antique light fixtures can be seen in the Chalet Suzanne Restaurant, the gift shop, antique house, the cottages, and all around the grounds. (Courtesy of Chalet Suzanne Restaurant and Inn.)

This aerial view of Lake Suzanne and the Chalet Suzanne Restaurant and Country Inn shows a section of the 120-acre property. In the foreground is the chalet's 2,400-foot, lighted private airstrip built in 1960 for fly-in guests. Over the years, many celebrities have flown in to stay at the chalet for privacy and luxury dining. A soup cannery also operates on the property. The restaurant's signature soup, created by Carl Hinshaw Jr., was taken to the moon aboard the Apollo 15 and Apollo 16 flights. Astronauts had flown in to Chalet Suzanne for rest and relaxation from spaceflight training at Kennedy Space Center. They requested the romaine soup be taken into space and, after testing, NASA agreed. It was also carried by the Russian cosmonauts for the Apollo–Soyuz link-up in space. (Courtesy of Chalet Suzanne Restaurant and Inn.)

DISCOVER THOUSANDS OF LOCAL HISTORY BOOKS FEATURING MILLIONS OF VINTAGE IMAGES

Arcadia Publishing, the leading local history publisher in the United States, is committed to making history accessible and meaningful through publishing books that celebrate and preserve the heritage of America's people and places.

Find more books like this at
www.arcadiapublishing.com

Search for your hometown history, your old stomping grounds, and even your favorite sports team.

Consistent with our mission to preserve history on a local level, this book was printed in South Carolina on American-made paper and manufactured entirely in the United States. Products carrying the accredited Forest Stewardship Council (FSC) label are printed on 100 percent FSC-certified paper.

MADE IN THE USA